AS I WALKED
AND OTHER CHRISTMAS POEMS

KEVIN CAREY

ILLUSTRATED BY KEVIN SHEEHAN

Sacristy Press

Sacristy Press
PO Box 612, Durham, DH1 9HT

www.sacristy.co.uk

First published in 2015 by Sacristy Press, Durham

Copyright © Kevin Carey 2015
The right of Kevin Carey to be identified as the author of this work has been asserted by him in accordance with the Copyright, Designs and Patents Act 1988.

Illustrations Copyright © Kevin Sheehan 2015

All rights reserved, no part of this publication may be reproduced or transmitted in any form or by any means, electronic, mechanical photocopying, documentary, film or in any other format without prior written permission of the publisher.

Sacristy Limited, registered in England & Wales, number 7565667

British Library Cataloguing-in-Publication Data
A catalogue record for the book is available from the British Library

ISBN 978-1-910519-16-5

www.jesus4u.co.uk

CONTENTS

Preface ..v
Musical Settings ...v

A Death and a Birth......................................1
Night Stories ..2
Advent Prayer ...7
Thaw..8
Advent Calendars..9
Advent Hymn .. 10
Ageing ... 12
Cloud .. 13
Christmas Day Is Coming 14
Call Centre ... 16
The Core ... 17
A Christmas Eve Reflection 18
Children's Christmas Songs 19
Cease to Pine ... 24
As I Walked.. 25
Past All Earth's Sweetness 26
Now ... 27
Scars ... 35
Old Austrian Hymn..................................... 36
Blesséd the Night 38
The Child and the Beggar 39
Pro Pastores.. 40
Squad .. 41
Just a Little Star... 42
Somebody Ought to Know 43

iii

My Lullaby	44
A Church in Bethlehem	45
Strange Complicity	46
The Comforter	47
Entwined	48
Old Charts Rolled Up	49
Ah Yes, A Lamb!	50
The End of Magic	51
Prophets	52
Conversation	53
All We Know	54
How?	55
Obscured	56
Luke's Lullaby	58
Ecology	59
Science	60
Something Funny Instead	61
His Baby Hand	62
Christmas Tune	63
As Simeon Speaks	64
Excess	64
New Year	66

PREFACE

As contemporary Christmas carol music becomes ever more melancholy, reaching almost naturally for the minor key, it is not surprising that this fourth collection of Christmas poems, written to provide composers with new raw material, should somehow have tended in that direction without my knowing it, perhaps exemplified by the profusion of lullabies which never quite escape the melancholy.

While I was writing, I could never quite rid my mind of the persecution of Christians in the Middle East and this had the indirect effect of showing me just how little we treasure Christmas, much in the same way that we have come to take almost everything for granted that is beyond the wildest dreams of most of the inhabitants of God's earth now and in every previous age. Indeed, without wishing in any way to condone the current violence, at least one cause of iconoclasm is a "puritanical" reaction to excess and so, though indirectly, they are linked. Yet, conversely, it is a contemporary fault to conflate reverence with seriousness and I hope there is just enough humour to leaven the lump.

Kevin Carey
Hurstpierpoint, West Sussex
Octave of Easter 2015

MUSICAL SETTINGS

As with previous volumes, the verse in this collection can be readily set to music and it is the author's earnest hope that some of it will. The author would be very pleased to hear from composers who may be interested in setting any of these lyrics. Please contact the publisher if you would like to do so.

A DEATH AND A BIRTH

Sonnet in memoriam Dave Coyle

For those who go with cold words to the grave,
Whose lives are ended with their earthly ends,
Thinking their only legacy is friends
And family picking for something to save;
And for those who determinedly face
Oblivion's prospect, both resigned and bleak,
Thinking a hint of godhead makes them weak
Rather than offering more mental space:
I like to think a Christmas card half-glanced,
The helpless baby 'posturing' as God
Touches a sense of something more than odd,
Potential, differently circumstanced:
Yet we are not the arbiters of grace,
All goodness will be held in Christ's embrace.

NIGHT STORIES

i.

See a princess rosy-cheeked and dressed in white,
 Dressed in white
In her castle tower shining marble bright,
 Marble bright
Fear the dragon breathing fireballs scaly red,
 Scaly red
And the wizard casting spells of doom and dread,
 Doom and dread.

Sing the song that carries all your future hopes,
 Future hopes
Love the world through microscopes and telescopes,
 And telescopes
Ponder all the wisdom of philosophy,
 Philosophy
Learn the lessons of the whole world's history,
 World's history.

Myth and wisdom fade before our new-born king,
 New-born king
Jesus Son of God, maker of everything,
 Of everything
Kneel beside the crib with shepherds and their sheep,
 And their sheep
Sing our song softly to help him fall asleep,
 Fall asleep,
 Fall asleep.

ii.

Keeping an inn is melancholy,
Dullness to dreams and then despair,
Wine deadens then revives the weight of care,
But I am expected to be jolly.

Always too much wine and not enough money,
Too much to do and never enough time,
I cannot make the awkward phrases rhyme,
And never say anything you would call funny.

I wasn't serious about the byre,
But next day when I looked they had all gone,
Leaving a strange impression hanging on
And me with inarticulate desire.

A strange old story always helps an inn,
Which explains why some sages sought us out,
Knowing more than us what it was about,
So fill your glasses and I will begin.

iii.

So fearful the sky,
So mighty the sound,
We covered our eyes
And fell to the ground:
The voice brought good news,
Or so its words said,
But we thought it untrue,
And feared we were dead.

So tiny the babe,
So radiant the star,
Which shone on his crib,
The door standing ajar:
We fell to our knees,
Still held in a trance,
And prayed for release
From this dread circumstance.

In a moment of bliss,
It all became plain,
We were heavenly blessed
With no need to explain:
But nothing lasts long,
Like the life of our sheep,
And we forgot the song
Which we learned in our sleep.

iv.

What is a wise man next to this child?
Books will fall short of what he will say:
We conned the figure but never the form
When we were far away, far away, far away.

Who rules the heavens, making such light,
Breaking the rules by which planets must play?
We posed the question but heard no reply,
When we were far away, far away, far away.

Why do our treasures now seem so small,
Laid at his feet, as his hands seem to pray?
We know the answer but never the form
Now we are far away, far away, far away.

V.

A song half way to heaven,
Star bright beyond all lights,
A prophesy half given,
Night far beyond all nights:
A child half dead from cold
Is king for evermore,
A world half mad with gold
Re-fashioned for the poor.

The song fulfils all hope
As brightness comes to earth,
The promise beyond scope,
Encompassed in a birth:
The grace of Christ Our Lord,
Earth's dignity made good,
Its tarnished state restored
By his own precious blood.

A man of no account,
With barely wit to lurch,
Makes his unsteady mount
Up to the midnight church:
Takes one last, gurgling swig,
Hides his flask behind a bush,
And kneels before the crib
In the reverential hush.

ADVENT PRAYER

As we await your coming Lord,
In quiet reflection may we pray
With penitence and humble heart
To make us worthy of the day.

Lord, we are not above the world,
Loving the fruits your bounty brings,
But seek some respite from good cheer
To fix our minds on higher things.

Our joy will bloom when you arrive,
The waiting will be worth the stay
Of revelry not in your name
Until you come on Christmas Day.

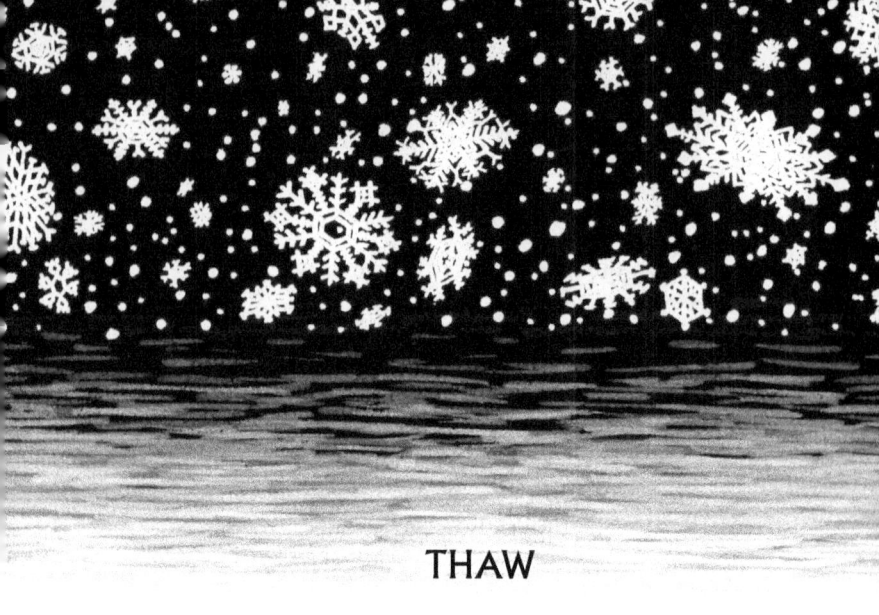

THAW

Come Jesus quickly. As the dark draws on
Our patience falters with the fading light,
Oppressed by plenty, glittered into gloom,
Bold artifice cannot withstand the night.

A grief like snow sweeps in across the plain,
Soft and diffuse yet cold in every flake,
Its thawing followed by the crack of ice,
Its treachery impossible to take.

Bring hay for tinsel, a manger for the sleigh,
Come quickly Lord, harbinger of the thaw,
Or else the cold will break my brittle heart,
Which longs to be with you forevermore.

ADVENT CALENDARS

Behind each tiny door
A chocolate awaits
The eager hands that tear
It from its glistening coat:
Where are the angels, where,
Who promise the divine,
In outline drawn and referenced
In a cryptic line?

Tomorrow is too late,
It must be ours today:
Bring everything we see
Unwrapped, without delay:
When church bells finally ring,
Our shallow ennui
Writes off the infant king
As ancient history.

ADVENT HYMN

1. Of God's unending, perfect love,
The child awaited, long foretold
By prophets in the blazing sands,
Prepares to bear the dark and cold:
First for his chosen people come,
His promise then outstretched to us,
That all might be embraced in in him:
A patre unigenitus.

2. Word before time of promised flesh,
A sketch in David and his sheep
Realised in Bethlehem at last,
The shepherd of the whole world's sheep:
Who came in quietness for peace
Beyond what our poor words can say,
None has nor will be great as he:
A solis ortus cardine.

3. Yet though he was of royal line,
The angel palaces eschewed,
Asking a maiden for her womb
As shelter for the Son of God:
"I am his servant," she replied,
"For what he wishes, I am fit."
In spite of scorn in human eyes:
Maria ventre concepit.

4. Shepherds and kings came in their turn,
As monarchs and the enslaved pray
To see the rose of Jesse's stem
Bring forth her child on Christmas day:
God's glory pent up in a star
Dispels the pall of man-made gloom,
Spreading its light both near and far:
Agnoscat omne saeculum.

5. O lux beata Trinitas,
As we make ready, may we clean
The stain of excess enterprise,
Clothing ourselves in humble sheen:
To you in heartfelt penitence
We wait, for him to show the way,
Knowing your child will save us all:
Gloria tibi Domine!

AGEING

Great losses for small gains
Are the accountancy of age,
A book of life once brimming,
Now a meagre, single page:
And all the smiles of decades
Pinched to futile, pointless rage.

Yet every year, defiant of time,
My rituals decree
An advent wreath, carols, the crib,
Gifts set beneath the tree,
To celebrate a timeless truth,
A promise kept for me.

CLOUD

All here facing our book
Of digital delight,
The networked stars all out
Upon this special night:
A tide of love and thanks
Compacted into texts,
Instant and full of grace
Beyond what aunt expects.

Dad's phone is obsolete;
Angels in 'selfie' rings,
Shun shepherds, as they should,
To photograph the kings:
The postings, thumbed on high,
The glittering cloud expands,
Vibrating constantly
With miniscule commands.

Real angels never cease
To read the pulsing mass
Of love and self regard
In clusters as they pass:
The Angel Gabriel says:
"The stable trend is slow.
It's time to tweak the cloud:
Make Jesus viral! Now!"

CHRISTMAS DAY IS COMING

Tell the tale of running deer:
Christmas time, Christmas time!
Spread the message of good cheer:
Christmas Day is coming.

Dress the tree and stack the shelves:
Christmas time, Christmas time!
Dream of Santa and his elves:
Christmas Day is coming.

See the new-born baby lie:
Christmas time, Christmas time!
Born for us, a mystery:
Christmas Day is coming.

Praise and generosity:
Christmas time, Christmas time!
Full of joy and yet holy,
Christmas Day is coming.

CALL CENTRE

A light shines where we least expect,
A song flows down the wire,
A heart grown cold in pleasure's grip
Bursts into cleansing fire:
The restless eye goes on the blink,
Grey steel breaks into red,
The history of faults wiped clean.
The tyrant screen is dead.

A baby in a manger lies,
Far from the pomp of Rome,
Soon to be made a refugee,
Far from his humble home:
His cruel death will save us all,
No matter how we fail,
Though callousness and knotted pride
His power will prevail.

A sudden light, a sudden child
Transforms the dark and cold,
An email from the refugee
That he will not be sold:
A church bell peals across the waste,
Too early yet to leave,
But I leave with a cheerful step,
For it is Christmas Eve.

THE CORE

Advent's waiting brushed aside,
Gone the long, repentant view,
Swallowed by the crimson tide,
Purple losing all its blue.

Lost the fast before the feast,
Sated long before the day,
Spending every year increased,
Scented candles in the hay.

Carols once sung at the door
Preen themselves as works of art;
Now consumed, whereas before
Praise flowed from an open heart.

Lord, help me separate the core
From sentimental fantasy,
That I may learn to love you more,
Discounting the periphery.

A CHRISTMAS EVE REFLECTION

Fast runs the race as the last evening falls,
Flash more than thought betrays the ritual's force,
Hurried affection grasped from glittering halls,
Fails to conceal the vulgar and the coarse.

Though faltering and short, better the prayer,
Like lips on stone, love makes rough places smooth,
Better the gesture of unhurried care,
The gloss of patience time will not remove.

Yet Jesus came to free those caught in briars,
Only he knowing how the seed fell there,
Better to leave him with their brash desires,
Better for us to fortify our prayer.

CHILDREN'S CHRISTMAS SONGS

i.

See the girl with her head bowed,
See the shining angel stand,
"Mary, I have come to greet you,
Sent to you by God's command."

"He would like himself made Jesus
As a baby here below;
Could you undertake this mission,
Jesus born for all to know?"

"I can feel the Spirit moving
Deep inside; I will obey,
Willingly accept God's promise,
Love the baby, come what may."

ii.

Clip-clop donkey,
Slip-slop donkey,
Trudging through the ice and snow,
Down the hill towards a tavern,
Welcoming with lantern glow.

'No room Joseph,
No room Mary,
There is no room here tonight;
All of you can share the stable,
Where I hope you'll be all right."

Little brother,
Baby Jesus,
Lying on a bed of straw,
Help us all to love each other,
Help us all to love you more.

iii.

The sheep were afraid of the trumpets,
As we were afraid of the light,
We heard a voice from the sky shouting
Good news; but it filled us with fright.

When all the drama was over
We went where a shining star led,
To see a babe laid in a manger,
Exactly as the angels said.

iv.

Lullaby sweet darling,
Sleep sound through the night,
Time enough to worry
With the morning light.

Our poor best we offer,
To lay you in a manger:
I would give my dowry
To keep you out of danger.

Lullaby sweet darling,
Song turns into tears,
Close your eyes, my darling
I can't hide my fears.

Lullaby, lullaby,
Lullaby, lullaby,
Sleep until the morning
Song turns into tears.

V.

Even the camels smiled for joy
At journey's end, at journey's end
As we first saw the little boy
At journey's end with Jesus.

We brought Gold, frankincense and myrrh
At journey's end, at journey's end
For our new king told by a star
At journey's end with Jesus.

We laid our presents at his feet
At journey's end, at journey's end
Thanked by his mother's smile so sweet
At journey's end with Jesus.

CEASE TO PINE

What a poor child to see
When there died two in three,
Ah me!

Why came he so poor
Who reigns for evermore?
Hurteth sore!

Lay he in the hay
That blesséd day
We kneel and pray!

King threatening a king,
Babes killed at his bidding,
Sadly we sing!

Mine all at rest,
Scarce from the breast,
How blest!

Cease I to pine,
Though divine,
This childe is mine!

AS I WALKED

I saw a lady dressed in blue
As I walked to-
wards Bethlehem,
Raising her head to see the view
Of Bethlehem, of Bethlehem.

I heard a new-born baby cry
As I walked by
In Bethlehem,
Beneath a wondrous, starry sky
In Bethlehem, in Bethlehem.

At midnight everything was still,
Climbing a hill
Near Bethlehem,
Then angels sang "good will, good will"
Near Bethlehem, near Bethlehem.

I had the sense of a new start,
Set to depart
From Bethlehem,
Of something stirring in my heart
From Bethlehem, from Bethlehem.

PAST ALL EARTH'S SWEETNESS

Past all earth's sweetness and accord,
Beyond desire and device,
The sacred mystery of Our Lord
Encompassed in a sacrifice.

No splendid palace to report,
Nor thundering statutes to obey,
But shepherds at his manger court,
A baby lying in the hay.

Christ in humility restores
What we have thrown away in pride,
Not with philosophy nor wars;
But cattle standing at his side.

No matter what the world believes
Is in its power to command,
All yet must kneel to receive
A blessing from a tiny hand.

NOW

i.

Called by the raging storm
Away from warmth and light,
They bravely fought their way
Into the raging night:
A climber on the fell
Mourning his wife, new dead,
Had spurned the Christmas cheer,
Seeking silence instead.

A burst of sudden grief
Induced a grave mistake,
He tumbled off a ledge
And felt both femurs break:
The weather worsened fast,
They almost turned away,
Hoping to start again
Prompt at the break of day.

But then they saw a light
Hovering overhead
Which drew them to a spot
Where he lay, almost dead:
It led them up a slope,
Bearing their fragile load,
But promptly disappeared
When they regained the road.

The angel of the night,
In memory of God's Son,
Finished the generous work
The rescuers had begun.

ii.

O how I wish we could find you a bed
All year round and a roof over your head,
But all we have is this shed for a week,
A shelter of joy when the season is bleak.

Here is a mince pie, a glass of mulled wine,
After the pudding I'm sure you'll feel fine:
Jesus is optional; don't get distressed:
All he would want is your comfort and rest.

Time to go now, we will see you next year
(If you survive, which is doubtful, I hear);
At Christmas our donors are willing to pay
But when it's gone, the goodwill ebbs away.

iii.

Tiny Tim looked in the window,
Saw the horses in array:
Wooden heroes bound for children
At the dawn of Christmas day.

Tim sees tractors in the window
But, diverted by the bread,
Turns his mind from shining presents,
Wishing he could eat, instead.

iv.

Lonely at the window, no-one plays
In the street on this family day of days,
Surfing a shallow wave of photographs
Where everybody smiles but no-one laughs.

A cup of tea, perhaps an hour of heat,
The supermarket meal ready to eat.
Why are the programmes different tonight?
She has a sense of something not quite right.

She dozes in a bath of canned applause
Which has something to do with Santa Claus;
And then she sees the baby in the hay
And knows why it is such a special day
And, waking up, she bows her head to pray.

V.

Welcome, this is Bethlehem,
Postcards, please, or something small;
I am eight and make the money
With this makeshift, little stall.

We are trapped within the city,
Work is scarce and times are hard;
Just a trinket, something pretty,
Oh, you only want a card!

When you see your baby Jesus
In the cave beneath our feet,
Tell him how you love the stranger;
How you gave her food to eat.

He was one and we are many,
But we live his story here;
Outcasts in an occupation,
Just a little souvenir?

vi.

Borne on the wind, a distant bell
More like a passing than Noel;
Good news for all, angels proclaim,
His coming makes us all the same:

O Jesus, if you came now
Your coming would be no less bleak
Than then:
Kyrie Eleison!

You came, that we should make you lord,
But we have not renounced the sword
And, added to such wicked kings,
We make so much of trivial things:

O Jesus, if you came now
Your coming would be no less bleak
Than then:
Christe Eleison!

Too weak to overpower thrones,
In thrall to temples made with stones,
Our ardour gutters out of sight,
Renew it on this Christmas night:

O Jesus, when you come
May your coming be happier
Than then:
Kyrie Eleison!

vii.

One star much brighter than the rest
Shines out above the city lights,
Its strength more powerful than all lights,
God's love in Jesus manifest.

No strength of arms nor cunning arts
Can overcome his steadfast love,
But there is just one place for love,
Not in the stars but in our hearts.

viii.

When the world grows dark and silent
And the last email is done,
I go home with cans and bottles,
Ready for a little fun;
But I place a tiny crib
Next to the television:
Putting the baby Jesus into Christmas.

I don't mind singing carols,
Most Christmas songs are stale,
Reindeer, sleighs and Father Christmas
On their silly global trail;
So the manger and the shepherds
Add some richness to the tale:
Putting the baby Jesus into Christmas.

ix.

Please let me in, the night is cold;
The town has turned its back on me;
But in your window there's a crib
Recalling Christ's nativity.

I am not quite the child you see,
My clothes are rough, but I am calm,
There are such dangers in the street,
Protect me from pursuing harm.

I see you disbelieve my tale;
Don't close the door against my plea!
Because in spite of how I look
It is the Christ Child that you see.

x.

As grows the acorn, so the child,
The manger that became a cross,
The hope that will not cower beneath
The weight of frippery and dross.

In slums and shoot-ups, baths and bars,
The story penetrates the vile
Excess of hopeless, doomed escape
To bring a momentary smile.

I am your maid,
Your will be done,
To bear the Godhead's blesséd Son:
The poor raised up,

The proud will dread,
The rich dispersed,
The hungry fed.

Pride kneels before a tiny child
And shepherds, who have little pride,
Give what they have in thankfulness
To stem oppression's roaring tide.

There is no snow to dress the dirt,
No motive for the rain of crime,
But in this tale they recognise
Hope in the DNA of time:

Blessed are the poor,
Blessed are the meek,
The pure of heart, the frail, the weak:
I am your strength,
Rejoice in me,
My suffering will set you free.

For one brief moment in the year,
Thoughts rise above the grime and gold;
So thick the gloom, yet there is light,
So strange the tale, yet it is told:

Of how a baby, born obscure,
Addressed us like a flag unfurled,
To give cheerfully to the poor,
Crowning him ruler of the world.

SCARS

Light on the golden straw
Casts shadow on a face;
Blood on the earthen floor
Betrays the price of grace:
Frost in the starlit air
Tailors fine coats of rime;
Shivering in the false glare,
The child feels the pull of time.

Doubts of the things foretold
Adulterates good news;
Scars in the pallid gold
Are melted, and then re-fuse:
Tears in a young girl's eyes
Alloy of motherhood;
Far from Olympian skies,
God made of flesh and blood.

OLD AUSTRIAN HYMN

Written in Vienna, 3 March 2014

O thou whom ancient seers foretold
Would light the dark and heat the cold,
Of David's line and Jesse's stem,
The morning star of Bethlehem
For us to shine
Was meekly in a manger laid,
Not carried in a grand parade,
His honour guard an ox and ass
Who let the humble shepherds pass
To worship human flesh divine.

Whose might surpassed the power of Rome
To reign here in our humble home,
Against whose armies no defence
Could withstand simple reverence
For God made man:
Whose triumph over death was so high
As low was his nativity,
Whose unimagined hope proclaimed
His mission for mankind regained,
To finish what his birth began.

Jesus, the wonder that you shared,
Our flesh can never be compared
With any other gifts of thine,
Though they are boundless and divine,
Not even grace,
For God incarnate moves the heart
In ways that words cannot impart;
This child exceeds all mystery
All creeds and all theology:
The logos in an infant's face.

BLESSÉD THE NIGHT

Blesséd the night,
Star-bright the sky,
Silence is pierced
By a new baby's cry:
High overhead
Angels pass by;
Mary is singing
A sweet lullaby.

Shepherds asleep,
Wake in a fright,
Thunderous words;
Mysterious light:
"Good news for all,
The future is bright,
Jesus Our Saviour
Is born on this night."

Blesséd the night
Hopeful the day,
Jesus lies next to
A lamb in the hay:
Wise men look out,
Still far away,
Trying to find where the infant
Will stay.

Blesséd the night
Hopeful the day:
Kneel at the manger
To wonder and pray.

THE CHILD AND THE BEGGAR

A white carpet for Winter,
And a crackling of frost,
A Christmas card picture
Whose beauty is lost
On the man in the doorway
Who shivers and prays
For a change in the weather,
The sun's pallid rays.

Wind cuts every corner
To savage the poor
Through cracks in the shutters
And under the door:
The new-born child shivers
And cries with the cold;
Even if he survives
He will never grow old.

The child and the beggar
Live under one star
Which illumines creation
Wherever we are:
Give warmth to the beggar
In the infant child's name:
Praise God in your kindness,
In thanks that he came.

PRO PASTORES

Simple, they say we are,
And some say outcasts, too,
But we are sprung of kings,
And Jesus is our due.

For, born of David's line,
A shepherd, king and priest,
He is our patron child
Who sleeps, warmed by a beast.

Magi may come and go
In costumes rich and rare;
But we will never go:
We will always be there.

SQUAD

Looking down from the sky
On a dusty old town,
Some sheep caught my eye
As I gently came down:
My angelic squad
All singing to God.

It would have been dark
So we made it gold bright
With a heavenly spark
For the glorious night:
I shouted "Good news"
Which was met with abuse.

I know shepherds are tough,
With a penchant to mock,
And the way we arrived
Was a bit of a shock:
But hard cash for booze
Reinforced the good news.

We sang them a chorus
To finished the show
And said spread the news for us
To those down below:
They were all so perverse
Pig-hands wouldn't have been worse.

JUST A LITTLE STAR

Just a little star,
Nothing very bright,
Breaking through the cloud
On a rainy night.

Just a little lamb,
Taken from the fold
Bleating for a smile,
Something warm to hold.

Just a little child,
Not an emperor,
Bringing love and hope
To the weak and poor.

Now a mega star
Lights our shepherd king,
Child and lamb and star,
Lord of everything.

SOMEBODY OUGHT TO KNOW

How the cold knifes through the wattle,
How the wind heaps up the snow,
How the straw tickles and prickles
In the candle's guttering glow:
Where have these poor strangers come from?
Somebody here ought to know.
I hear the cry of a baby,
When are they going to go?

Have you ever seen such a bright comet
As that hovering over the byre?
Just listen to those shepherds out there
Shouting as if there was a fire!
The youngest, there, what did he say?
Something crazy about the Messiah,
Good news for poor people like us,
Announced by an angelic choir.

MY LULLABY

La-la la-laa,
Sleep for a while,
And when you wake
We shall both smile
For we were born
Each for a trial.

La-la la-laa,
Dreams bitter-sweet:
What was proposed
Must be complete;
A mother stands
At her son's feet.

La-la la-laa,
Wake to the cry
Of angel-song
Passing us by:
What of me when
You go back to the sky?

La-la la-laa,
My lullaby.

A CHURCH IN BETHLEHEM

A church in Bethlehem is razed,
Leaving no stone upon a stone,
No sign that this was sacred ground
Where mercy was both sought and shown:
The Sunni storm will not blow out
Until Christ's legacy is blown
Body by body into pulp
So that His name will be unknown.

STRANGE COMPLICITY

Sweet infant sleep to shun the cold,
To spare you from the soldier's tread.
I'll sing a lullaby of old
And watch you in your humble bed:

How prophets with their blazing eyes
And crazy ways foretold your birth,
Of how through me you would be born
The King of Heaven to save the earth.

I wonder if I would have given
Consent to the bright angel's plea
If I had known we would be here
In exile, cold and poverty.

But I will sing the lullaby
Born out of strange complicity,
That you are what they say you are,
The Messiah of all; and me.

THE COMFORTER

Although the harrowing cries ring down
The ages as their mothers cry,
Herod's is but a petty crown
Which caused the Innocents to die.

The baby that escaped his wrath
Has checked the wrath of countless kings,
Directing them along the path
Of self-denial and suffering.

No general has had such troop,
No emperor such mandarins,
No love so humble when it stoops
To pay regret for faults and sins.

His parents carry him in flight
As soldiers torch their empty home,
Yet he will overcome the might
Of ancient and imperial Rome.

Yet, though it seems to quail before
The might of secular estate,
Love is the ornament of law,
The comforter that will not wait.

ENTWINED

Strange skies bring trepidation,
The promise taking time to crystallise;
Each minute calculation
Attempts to curb the margin of surprise:
And we, all stirred by nagging discontent,
Look up again and wonder what is meant.

Strange roads bring aggravation,
Graft far outweighing hospitality,
Sneering and provocation
Enhancing moments of sincerity:
But we, now star-ward driven, never look back,
Gripped by the prospect, not by what we lack.

Strange smiles bring consolation,
For what appears an inauspicious end;
We kneel in veneration,
But wonder what conflicting signs portend:
Death and new life entwined upon his chart
A dismal finish for a glorious start?

OLD CHARTS ROLLED UP

Our sought Messiah found,
The end of all our wandering,
A project bold and grand
Complete, a child slumbering.
Our garish gifts,
Products of so much posturing;
Pomp, war and death,
Statements much more than offerings:
Yet we are rich
In wisdom for our home-coming,
Old charts rolled up,
For a new beginning.

AH YES, A LAMB!

Ah yes, a lamb!
For which there is no mercy nor regard,
But if it is lucky a fleeting affection
Before its blood is poured.

Ah yes, a shepherd!
From whom so many stray for power and gold,
But if they are sorry for a fleeting moment
All will be reconciled within his fold.

THE END OF MAGIC

Stop for a prayer
To mitigate some feared riposte;
He is not there
To compensate what you have lost.
The Saviour's care
Puts God and humankind in place;
In full repair,
Magic is overcome by grace.

PROPHETS

From where you are,
Half desperate in the dark,
Can you see one bright star,
The Messianic spark?

He is what drove
You to such desperate speech,
A bow of love,
Shining beyond your reach.

Power and wealth?
No warrior, nor a king,
Who gave himself:
A perfect offering.

Now content rest,
Your prophets' work is done;
Israel is blest
In Jesus, God's own Son.

CONVERSATION

Where is the new-born child
Born long ago?
Is he a little lamb
Lost in the snow?

Nay, all the stars proclaim
He is alive.
He lives in David's name;
He will survive.

Send soldiers after him
And all his peers;
May David's lamp grow dim,
Sodden with tears.

Though blood flows in the street
That lamb has fled,
To sit in David's seat
When you are dead.

ALL WE KNOW

It would be strange to see a red
Rose petal on the snow,
Easier instead
To see a snow flake drifting
Towards gore:
Yet the rose
And the blood
Re-oriented
Godhead and motherhood.

It would be strange to see a star
Obscure all other light,
Easier by far
To see thousands of stars bright
Autonomously:
Yet the star
Of the stars
Created
Wonder and harmony.

It would be strange to see a white
Rose petal on the blood,
Easier, in spite
Of sophistry, to see blood lying
On the snow:
Yet the petal
And the star,
The blood
And not the snow are
All we know.

HOW?

How shall a rose so fair and full as this
 Bloom in the depth of Winter?
How can a stable radiate such bliss?
 Pray, may we softly enter?
The mystery veiled in mundane things declares
 God in all things,
 Answering our troubled prayers.

How shall a child so weak and poor as this
 Blossom in hail and thunder?
How can God's Son fall to a traitor's kiss?
 Pray, may we stand in wonder?
The mystery of the child who will not die,
 From earth-bound chrysalis
 To heavenly butterfly.

OBSCURED

Brave sages by a star
To Bethlehem were led
With gifts both rich and rare
To honour what they read;
Yet if the weather lifts
Will we then brave the street
To bring ephemeral gifts
And lay them at your feet?

The icons of desire,
Blinking with cheerful light,
Dissemble to inspire
And turn out to be trite;
History repeats itself
But we prefer the freak;
Our books stay on the shelf
As we pursue the chic.

Yet for all of our sins
—Which we would not call such—
When Christmas time begins
Our hands relax their clutch;
The manger child commands,
Obscured by glitz and glare,
The opening of our hands,
Though we don't know he's there.

LUKE'S LULLABY

Far from our comforts,
Out of the way,
Here you are lying
Upon meagre hay.
Not like the angel
Implied it would be,
Israel's Messiah
Born in poverty:

Long journeys over;
Back to the loom,
All the dear things
In our own little room.
Sharp the priest's warning,
Sharper by far
That my heart should bleed
Because of who you are:

Manger for cradle,
Such a wild start,
Rock with my singing,
Rock in my heart.

Manger for cradle,
Routine restored,
At least for the present,
My son and my Lord.

Think of the angel,
The star shining bright:
Laugh with the shepherds,
Jesus, Goodnight!

ECOLOGY

As polar ice crept down the glens,
Stretching its claws across the fens,
Our Christmas pictures turned from sand
To snow across the Holy Land.

Now, with polar catastrophe
Drowning the fens in rain and sea,
Will cards, now digital, please note,
Depict the manger on a boat?

If, then, the climate change extends
So that the temperate rainfall ends,
Will Christmas in the Holy Land
Revert to barren rock and sand?

SCIENCE

Through the bright mayhem of desire
And the cacophony of will,
A child's cry probes an awesome sky,
And, for a moment, all is still.

Through shallow fact and deep mistrust
Of anything man cannot prove,
A choir of angels stills the rage
Of self regard and sings of love.

And through the glitter of the age
Where light dispels a lurking fear,
A smoking lantern in a cave
Announces Jesus Christ is here.

As God's desire we are too grand
To be reduced to simple proof,
The mystery of why we are
Brings us much closer to the truth:
Science cannot prove but should discuss
God clothed in human flesh for us.

SOMETHING FUNNY INSTEAD

Why do they put church on the telly?
When they know that religion is dead?
Hand me the remote just a minute,
To find something funny instead.
Yes, I know that it wouldn't be Christmas
Without Jesus lying in the straw,
But it's only a story for children
Nobody believes any more.

HIS BABY HAND

His baby hand that clutched at straw
Was nailed against coarse wood for me,
Thus, being born an outcast waif
Was the least of his infamy:
The infant eyes that closed in sleep
Grimaced in pain to set me free,
The exile from King Herod's wrath
Was suffered for my liberty.

His cry that crept into the night
Screamed in distress with every blow,
The breast he sought for nourishment
Shuddered with grief to see him so;
The body wrapped in swaddling clothes
Too early wound in bands of woe:
And yet God's Son who died for us
Is God and king of all we know.

CHRISTMAS TUNE

*Approximately after Paul Simon's American
Tune, approximately after Bach*

It's not so much the snow of Winter,
Nor chestnuts on the fire,
Nor yet the clementines and walnuts
Of long constrained desire;
But the close-knit understanding
Of what's going on I miss:
Remembering Jesus in a stable, cold and dark,
And a snatched mistletoe kiss.

Now that the presents in a pyramid
Won't fit below the tree,
Perhaps because Jesus Christ and Santa Claus
Have lost their mystery?
Or maybe we enjoy too much
Of what we want the whole year long,
In spite of all the surface bonhomie,
There's something going wrong.

What makes things special is their difference,
Not heaps more of the same,
So in our down-to-earth enslavement
We need a simple game:
Call it Santa or Jesus,
We need something to believe,
And if we forget how to understand ourselves,
The world will be left to grieve.

AS SIMEON SPEAKS

As he foresees her pierced heart,
Turning our minds from crib to cross,
The age of innocence is cut short:
A sad but necessary loss.

For this is when the magic ends,
The sweet grown sad, the dark grown dense,
The wonder child by human hands
Is murdered for his innocence.

And she who holds him here today,
Simeon says, will hold him again,
A mother seeing her baby die,
Praying for the death to end his pain.

And we, like children, mourn the loss
Of candles, and then walk away,
Bypassing Jesus on the Cross
To meet him next on Christmas Day.

EXCESS

Bring straw for tinsel laid within a manger,
Where there were twinkling lights, a great star shines:
That tree so bright with baubles bears our saviour
Who dragged his wooden sleigh across the stones.

Crimson Santas bring good news dressed as shepherds,
While in-store wizards seek a hidden king,
The schmaltz of malls turns into wistful carols
So that we stop and listen to the song.

The child who came before the light and colour,
Bringing new hope, not frippery and dross,
Smiles at our gaiety with calm indulgence,
As he surveys our excess from his Cross.

NEW YEAR

Pianissimo
Time to go
Status Quo
Clocks slow
Red lights glow
Debts grow
Neighbours know
Spirits low
Patches show
Dead mistletoe
Bins overflow
Santa dumped in dirty snow.

EU GPSR Authorized Representative:

LOGOS EUROPE, 9 rue Nicolas Poussin, 17000 La Rochelle, France

contact@logoseurope.eu

www.ingramcontent.com/pod-product-compliance
Lightning Source LLC
Chambersburg PA
CBHW070451050426
42451CB00015B/3435